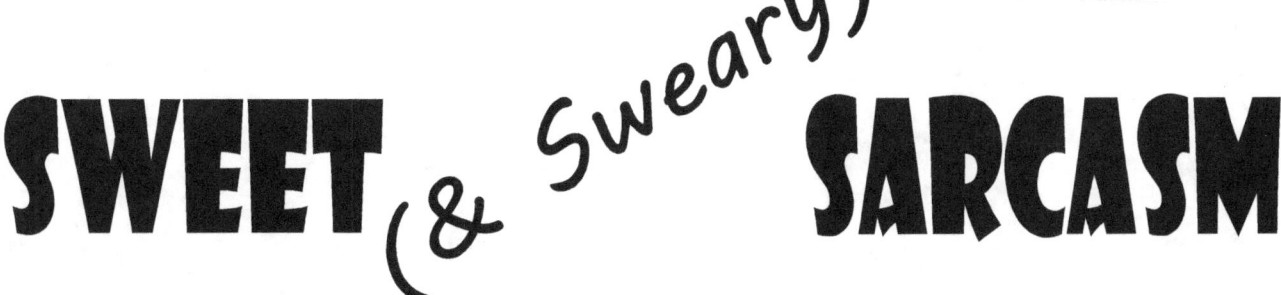

SWEET (& Sweary) SARCASM

An Adult Coloring Book

Jeri Artal

Art by Artal Creation

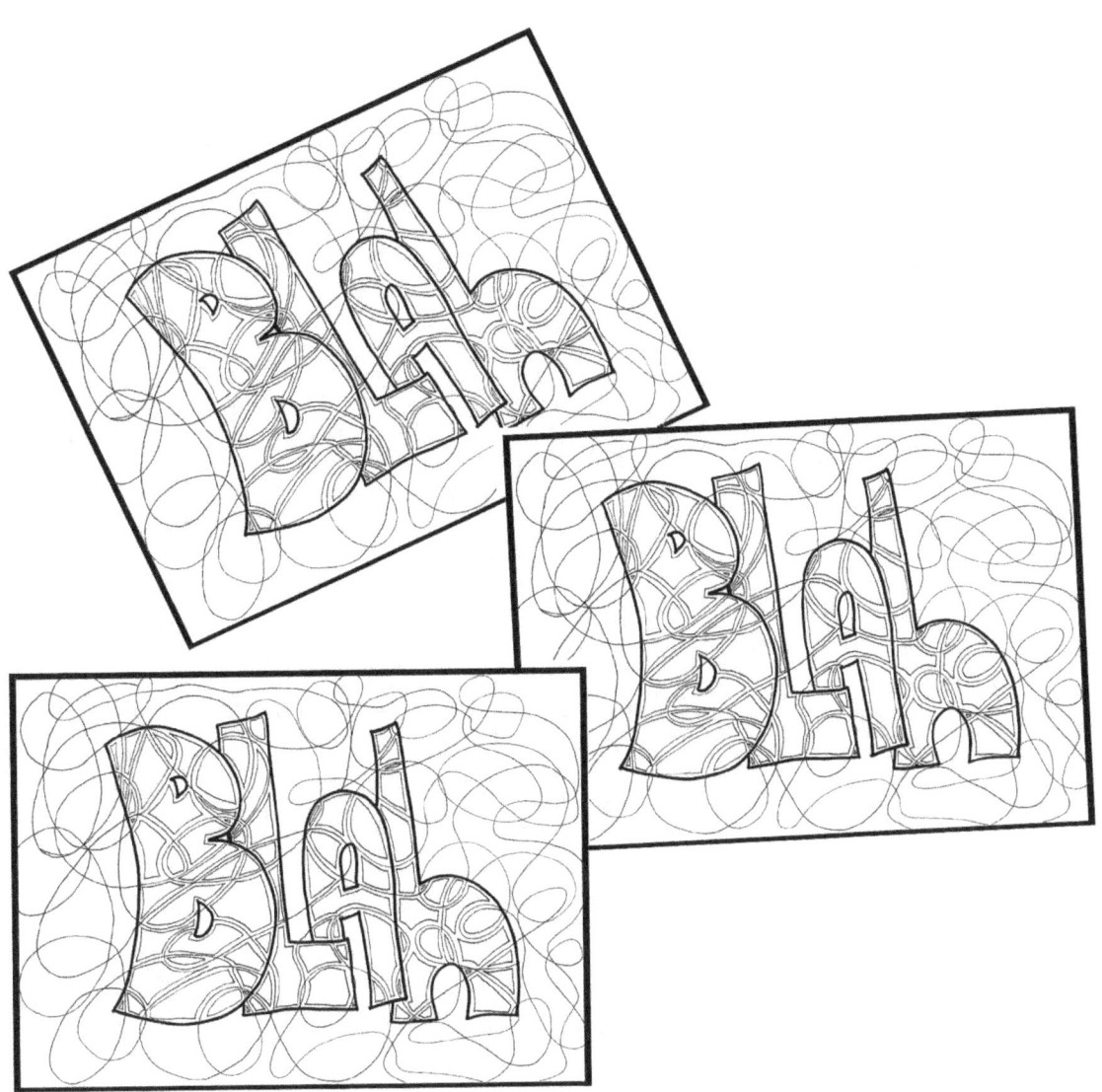

These drawings are covered by Copyright.

Copyright promotes creativity and protects the artists.

Please don't copy scan, transmit, share or attempt to pass them off as your own.

Jeri Artal is a (mostly) sane individual who will probably agree to most reasonable requests that are accompanied by a heartfelt "pretty please", anyway. Just Ask!
Many Super thanks to Molly Wee for coloring the cover!

Tips and Cool Info

As coloring becomes more and more popular, the methods of which it is done expands and increases. Here are some thoughts from the artist:

- Trust your gut and have fun. If you aren't having fun, please don't give up. Maybe you just need a change up? To this end, use whatever types of books (portraits, animals, detailed, not, etc.) and materials (pencils, markers, gel pens, paints, etc.) that you love. Don't worry about your skill level or anyone else's. Just enjoy yourself.

- The only opinion of your work that truly matters is your own. (unless you are in a class or something).

- There are SO many places to get information...YouTube, Facebook, blog pages, and websites. If you want to learn more about anything specific, it's probably out there. Not only that, but my experience is that the coloring community is one of the most helpful, loving and considerate communities there is. If you seek help, you can't help but find it!

Also:

- The back of this book contains pages for testing markers and gel pens (put at the back so it doesn't mess up any pages up front)

- Follow me on Facebook at https://www.facebook.com/ARTbyArtal/ and www.instagram.com/ARTbyArtal and show off your finished work!!

Now, on to the fun stuff! Let's color!

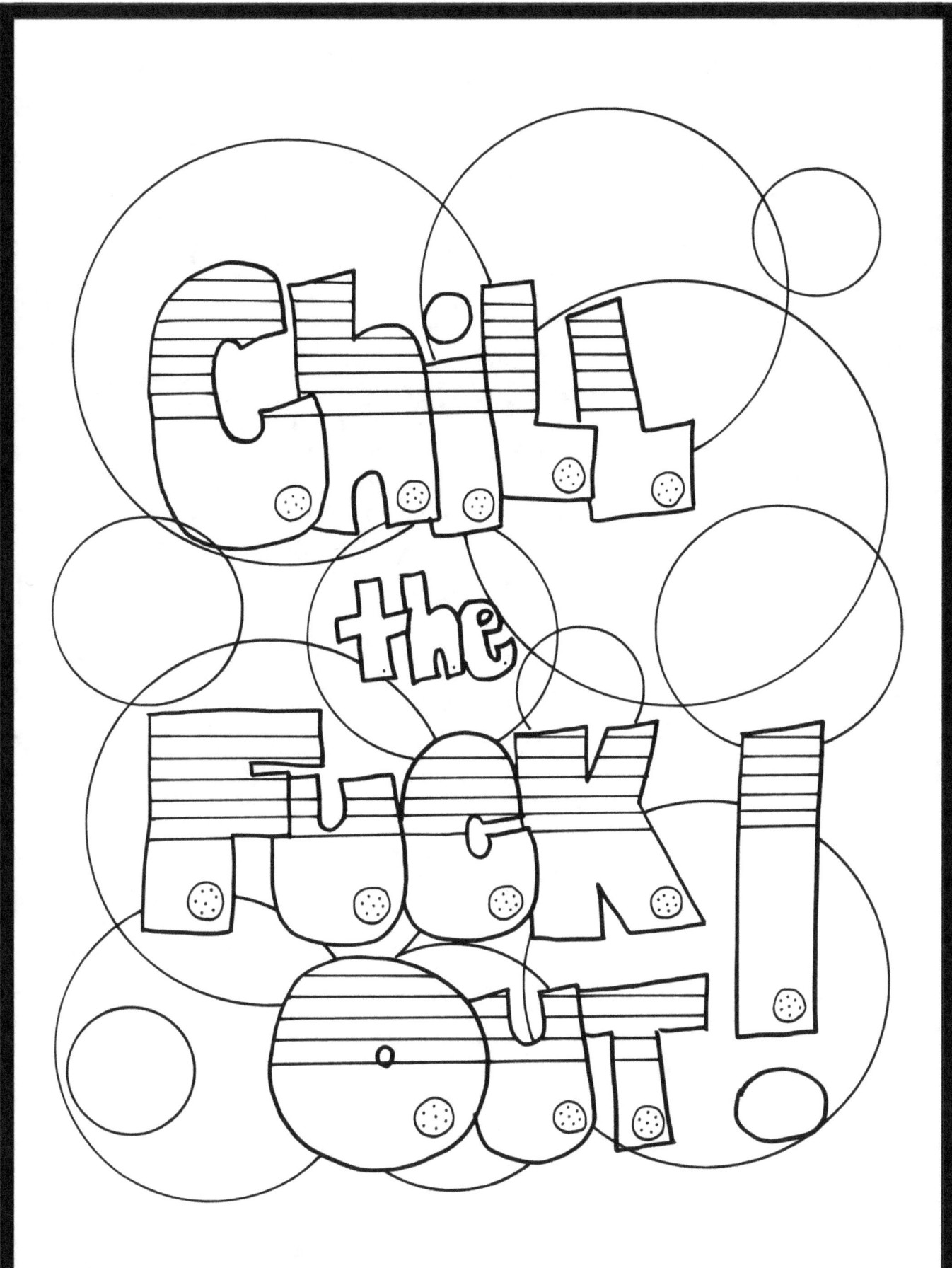

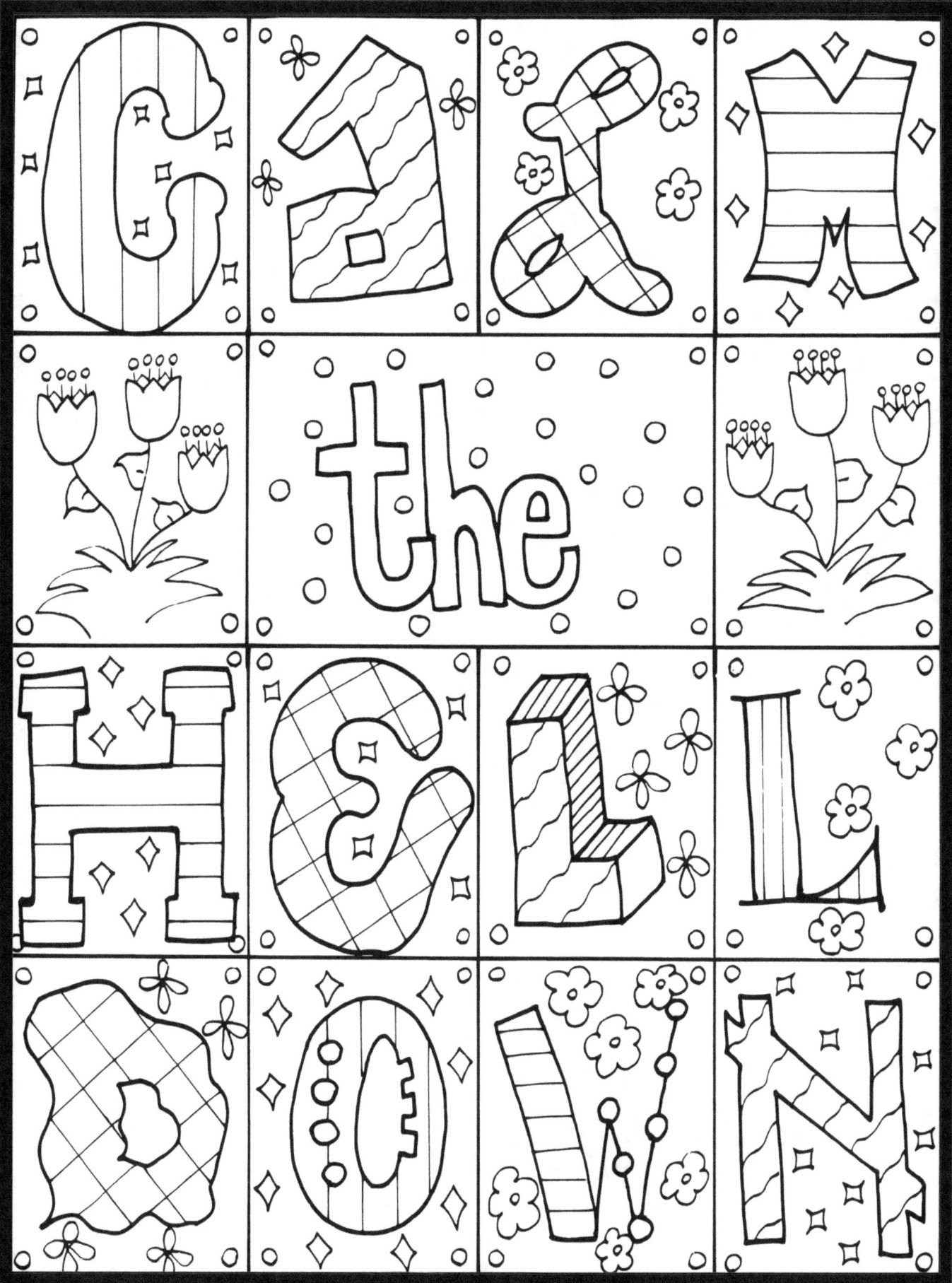

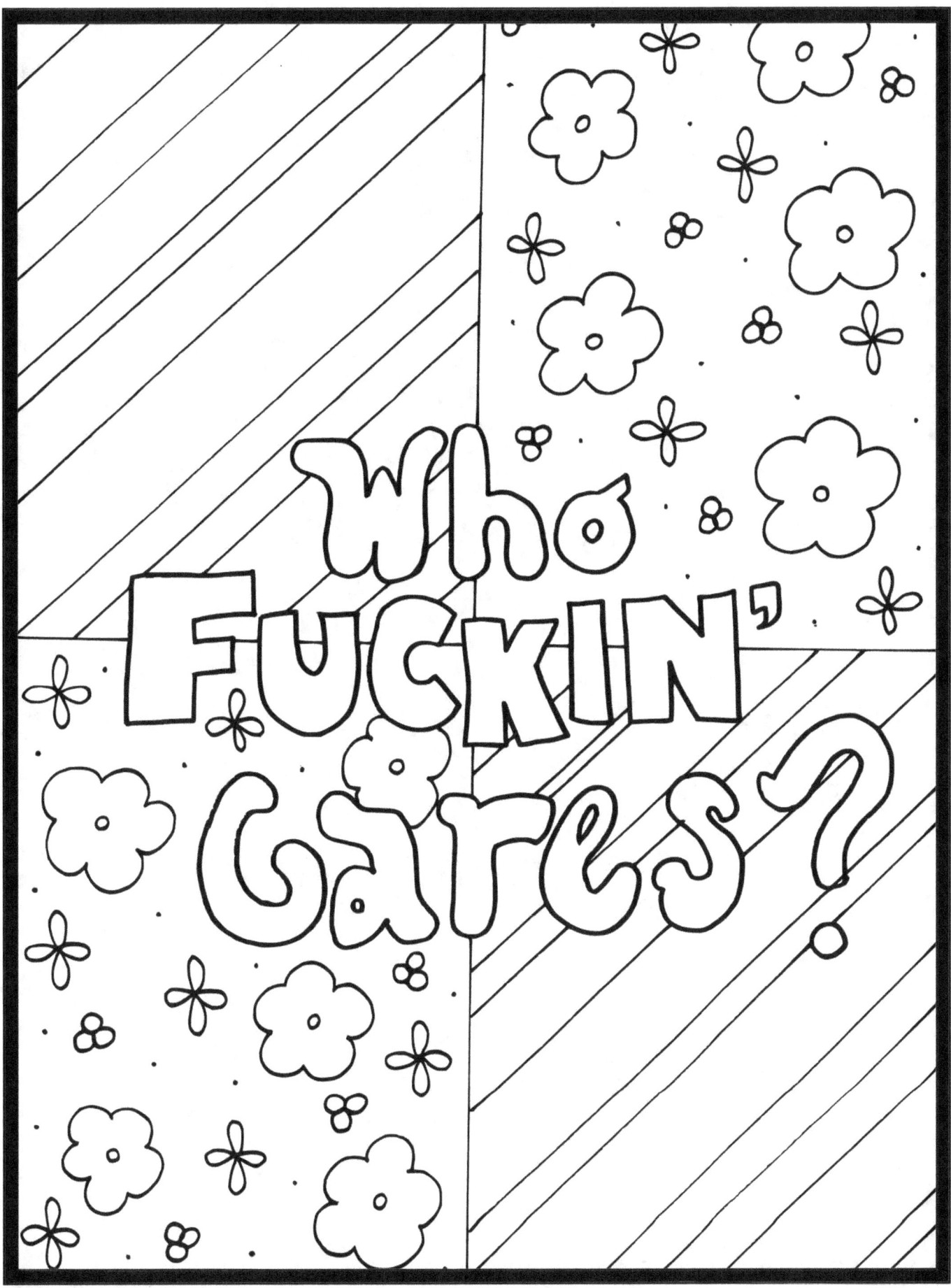

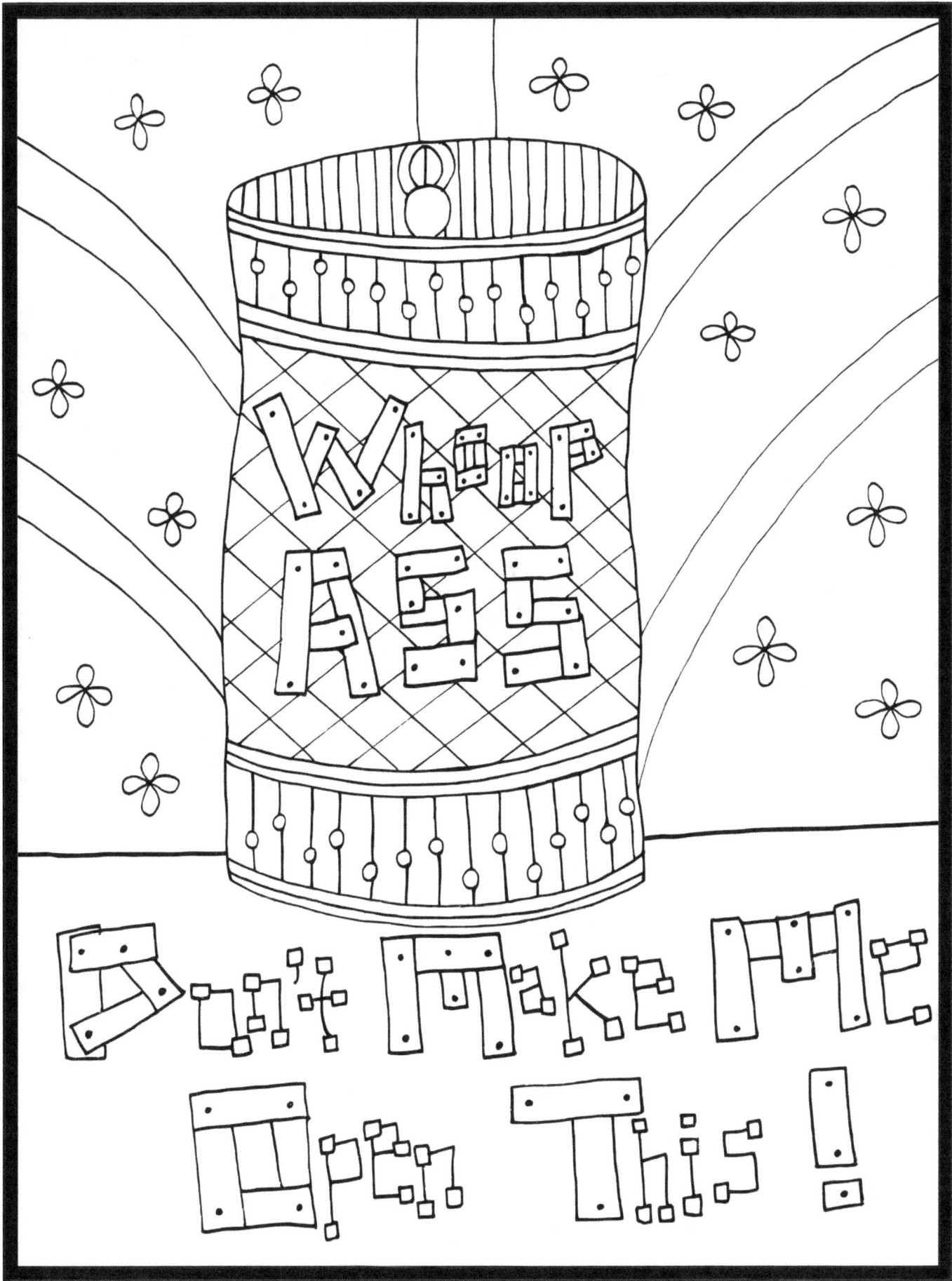

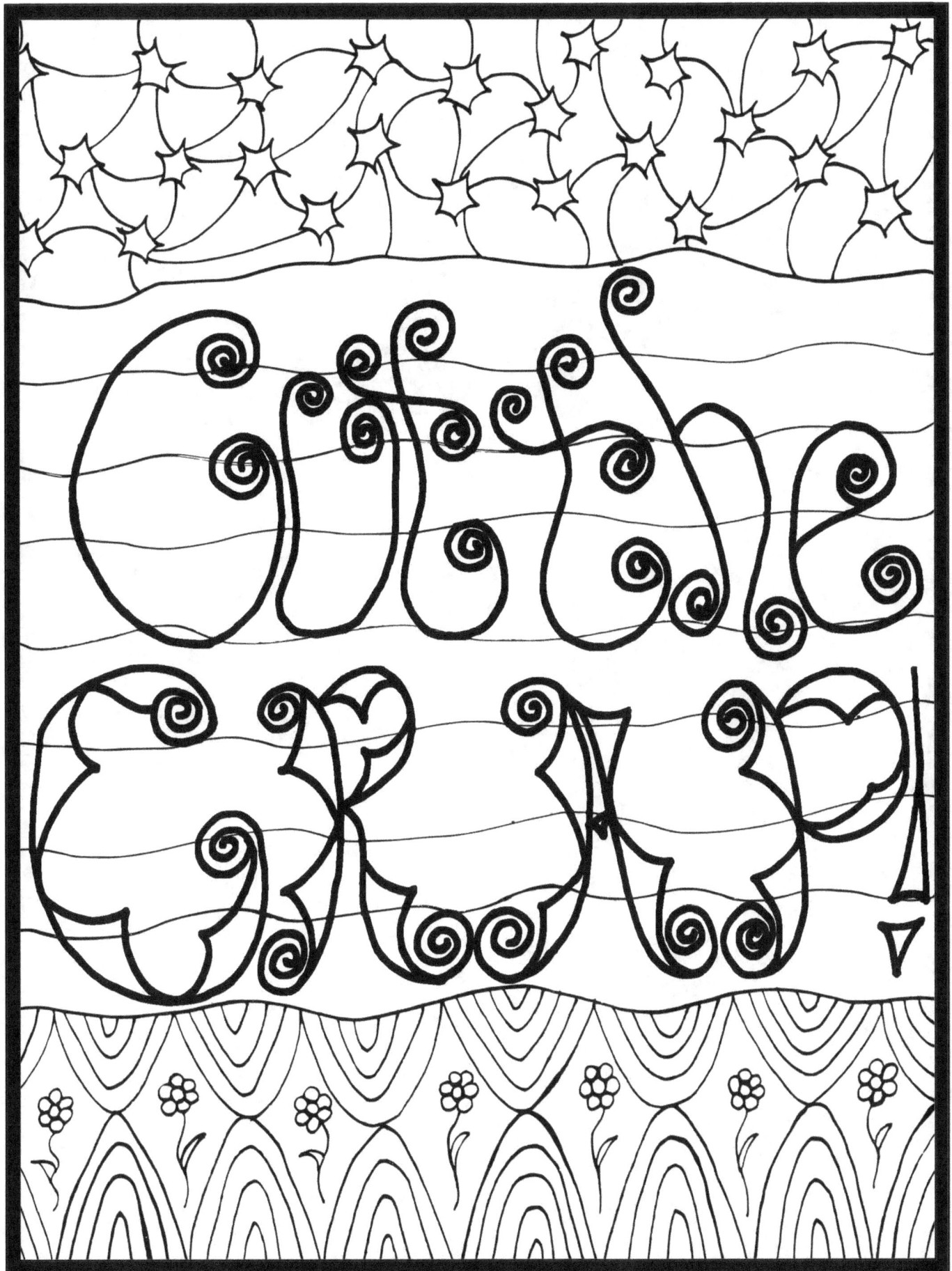

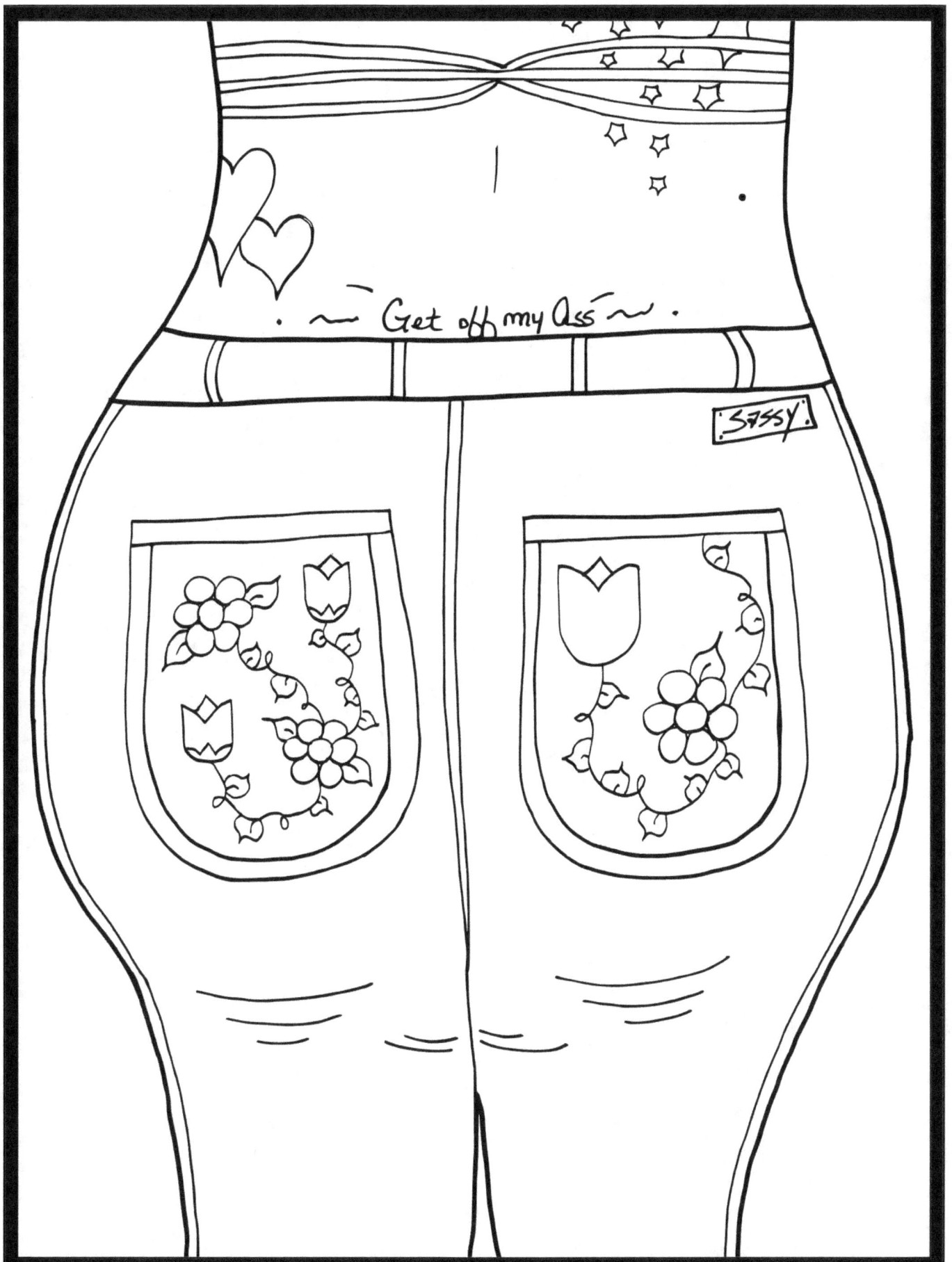

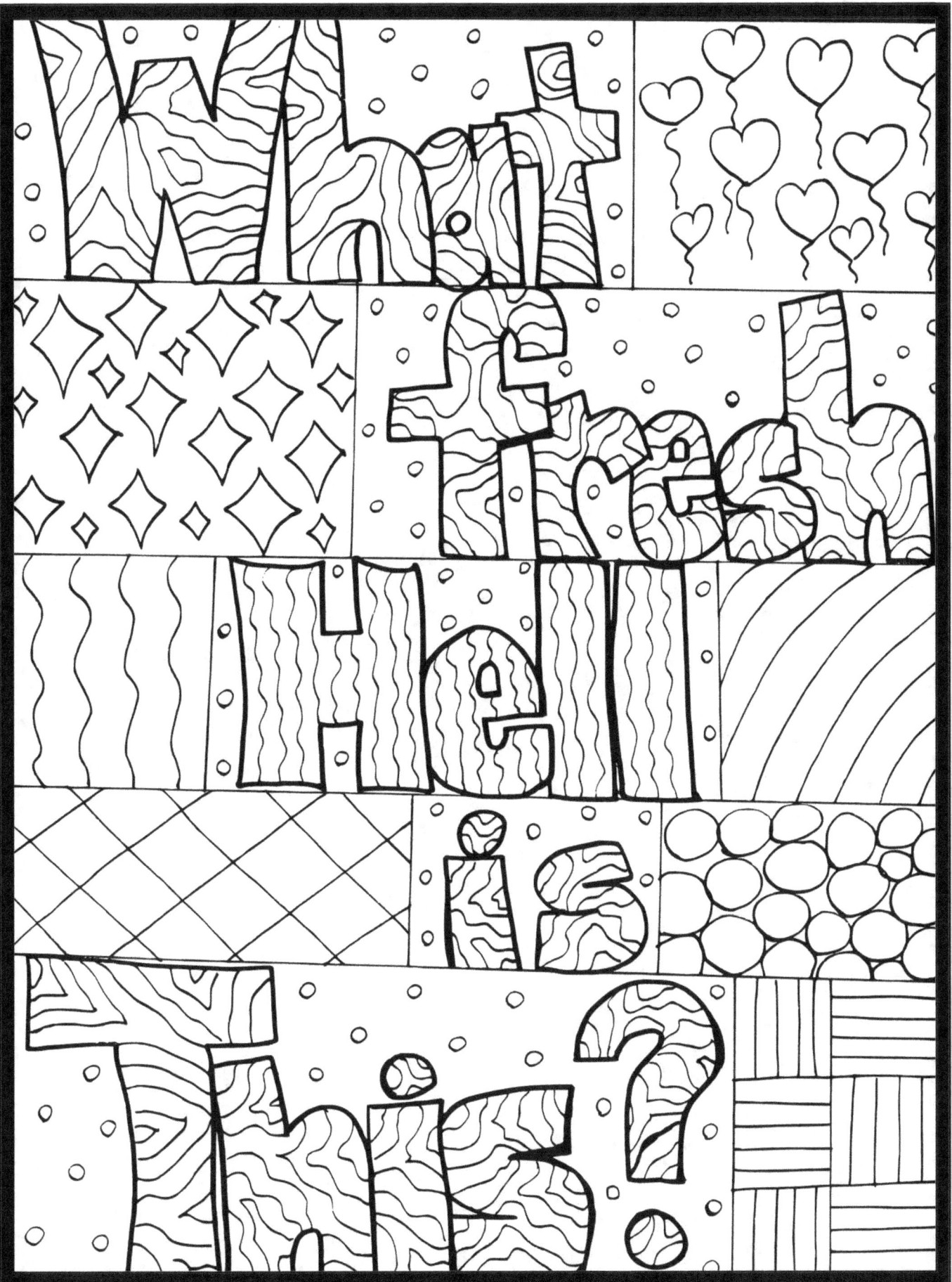

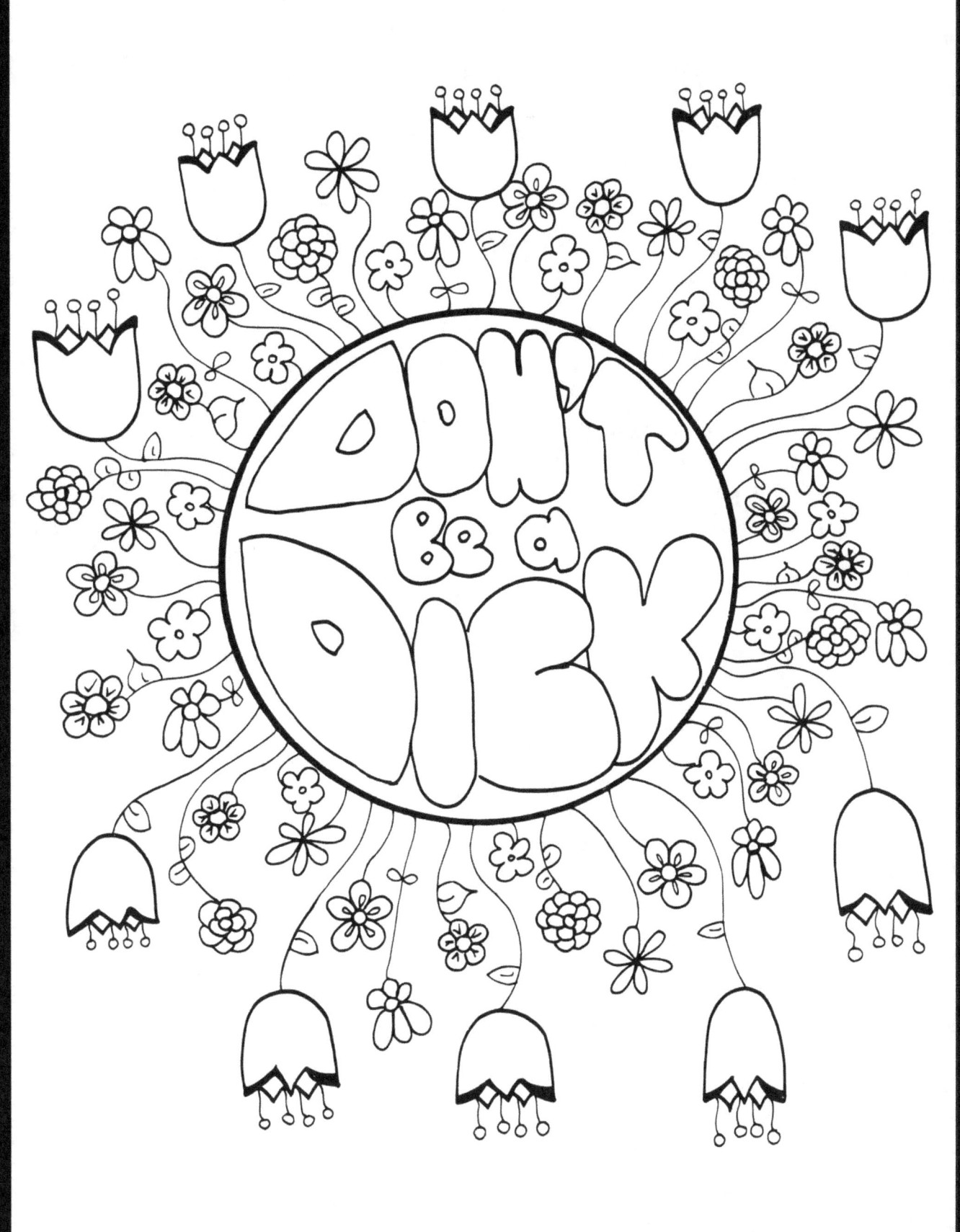

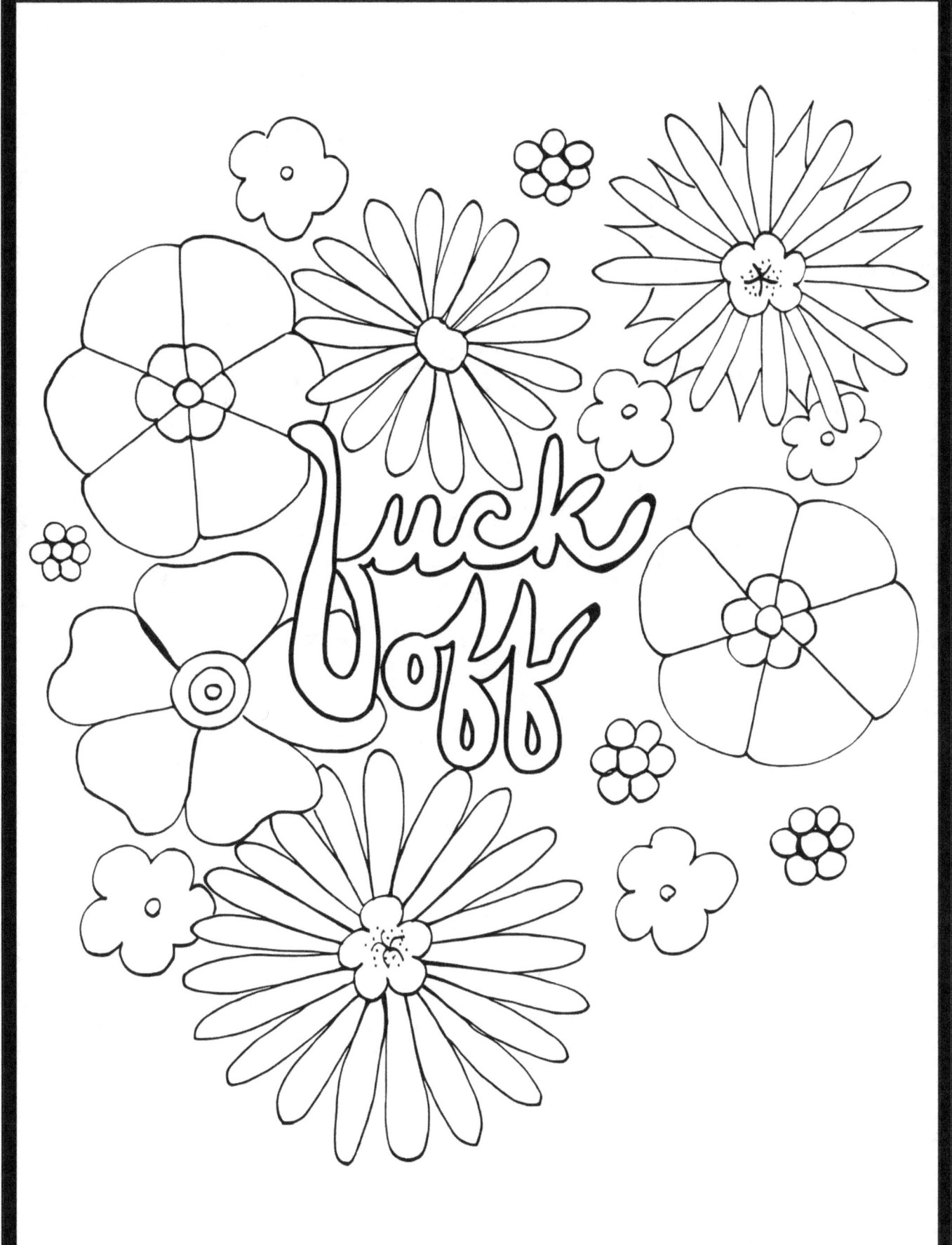

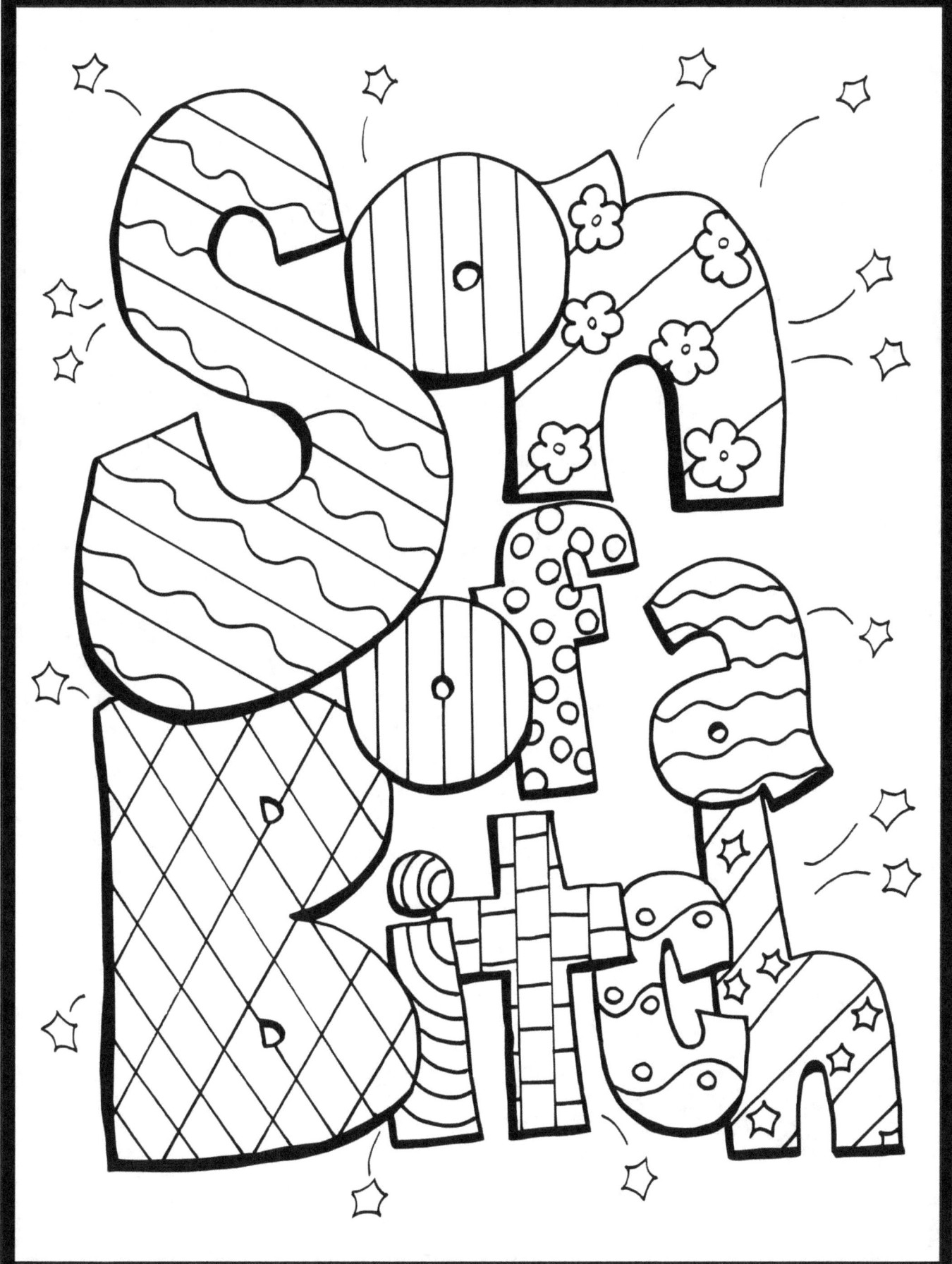

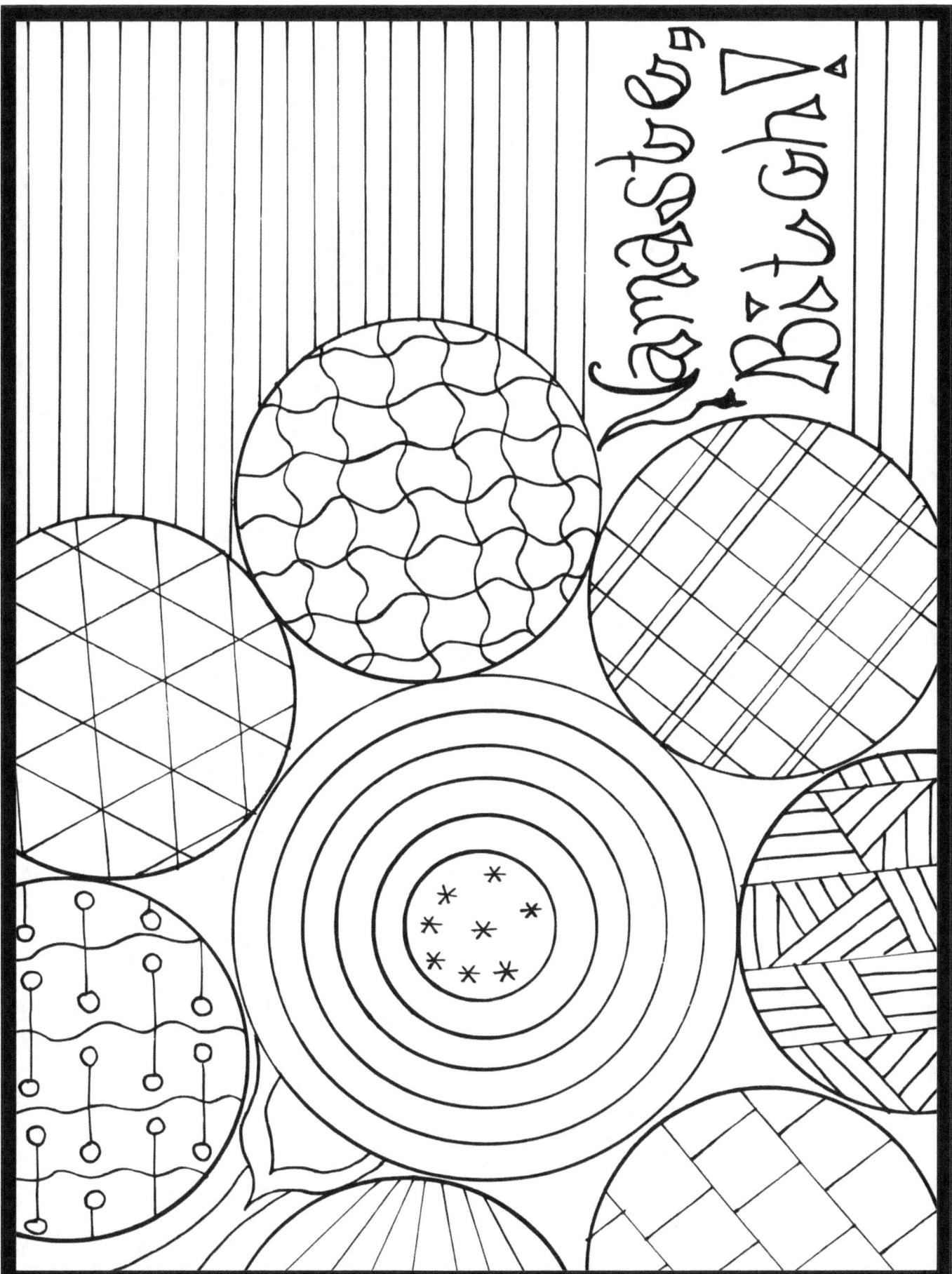

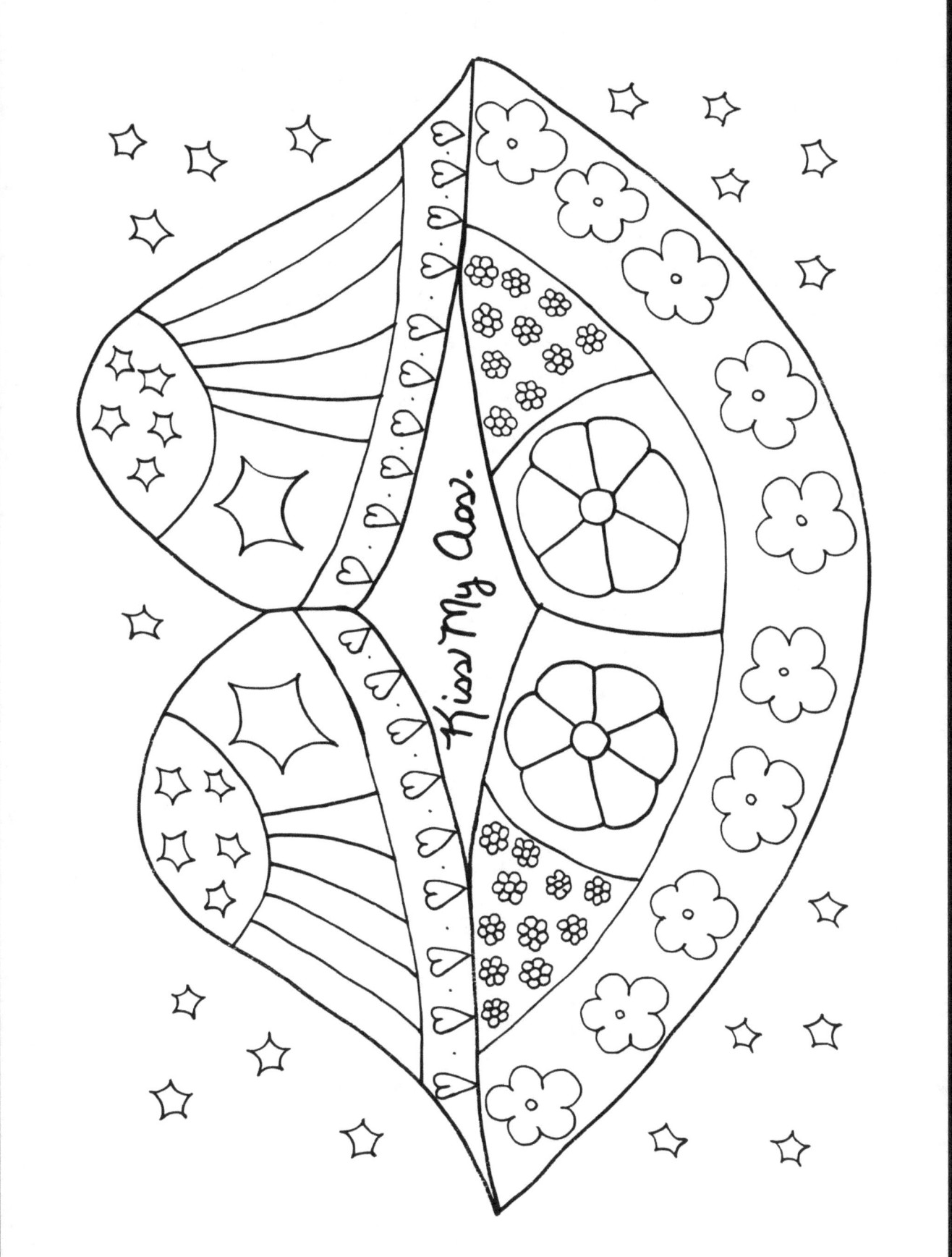

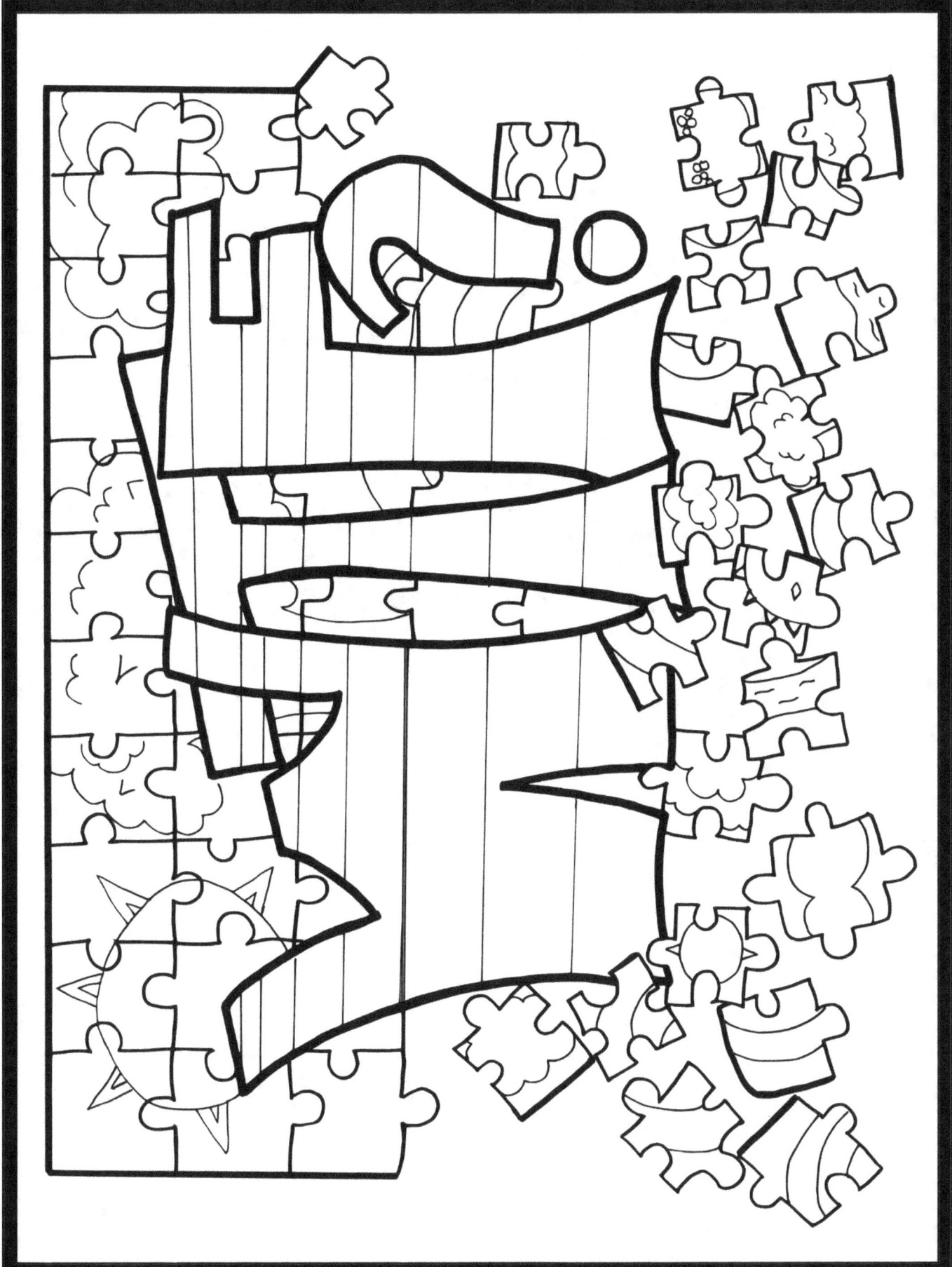

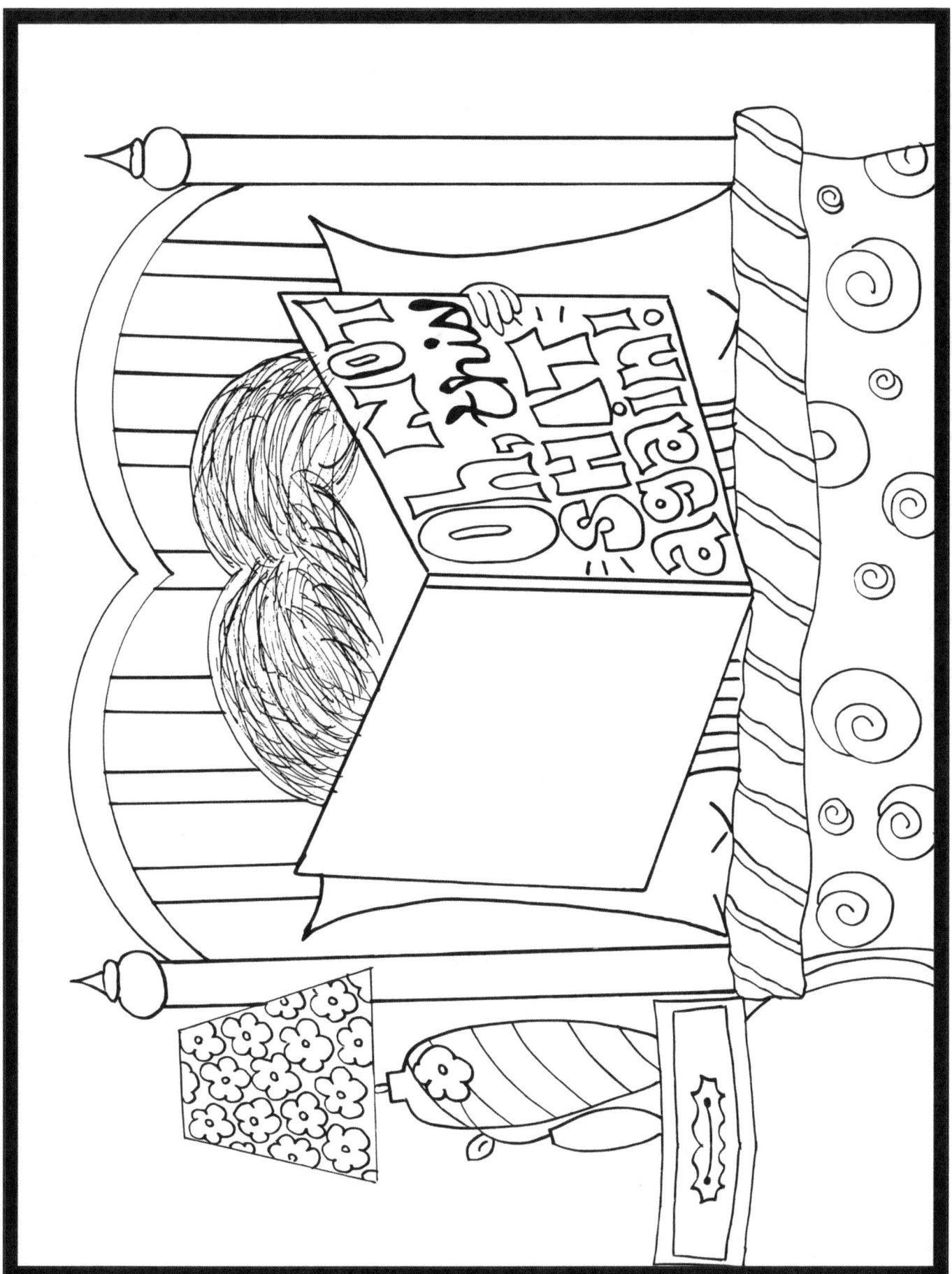

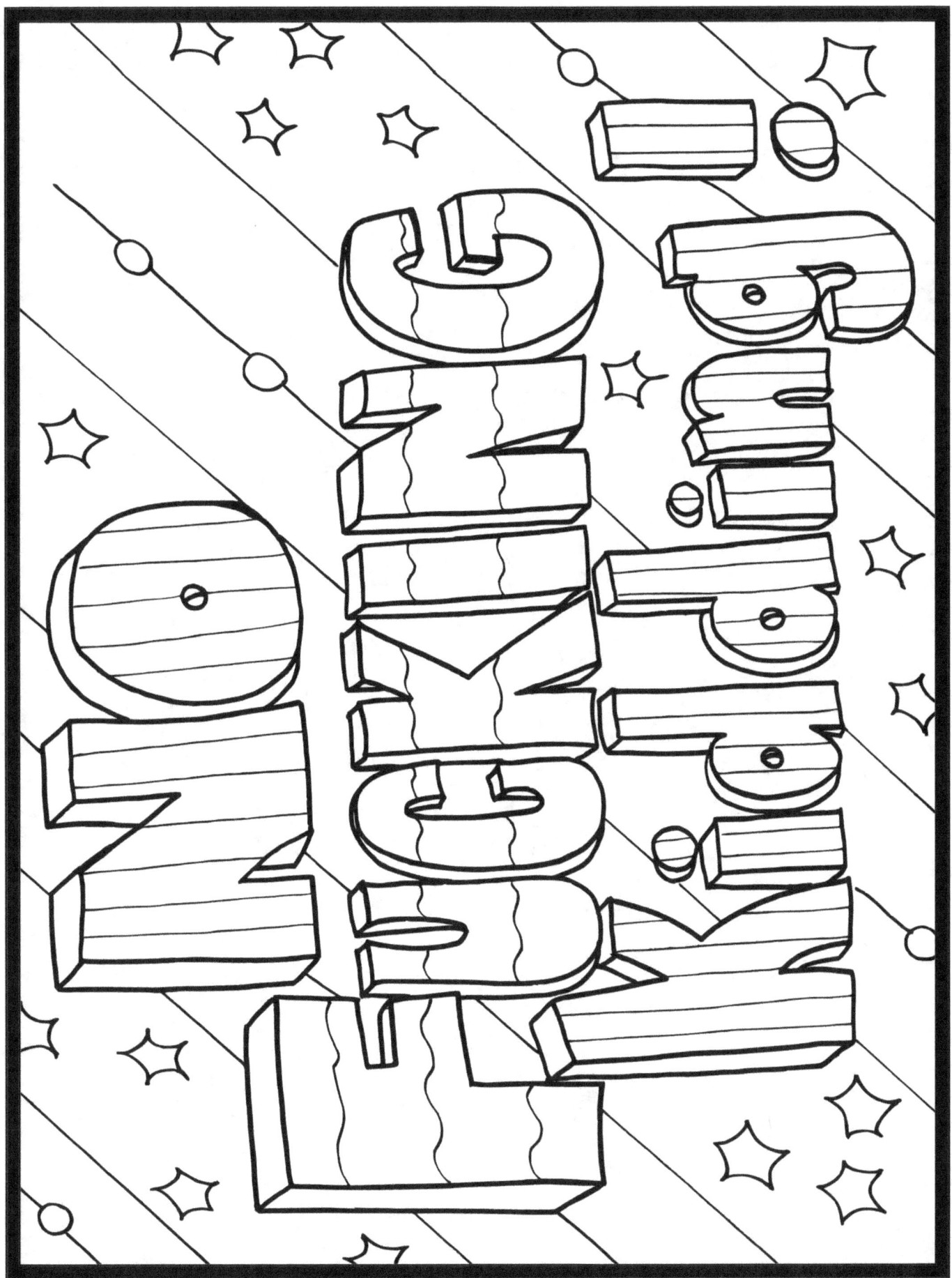

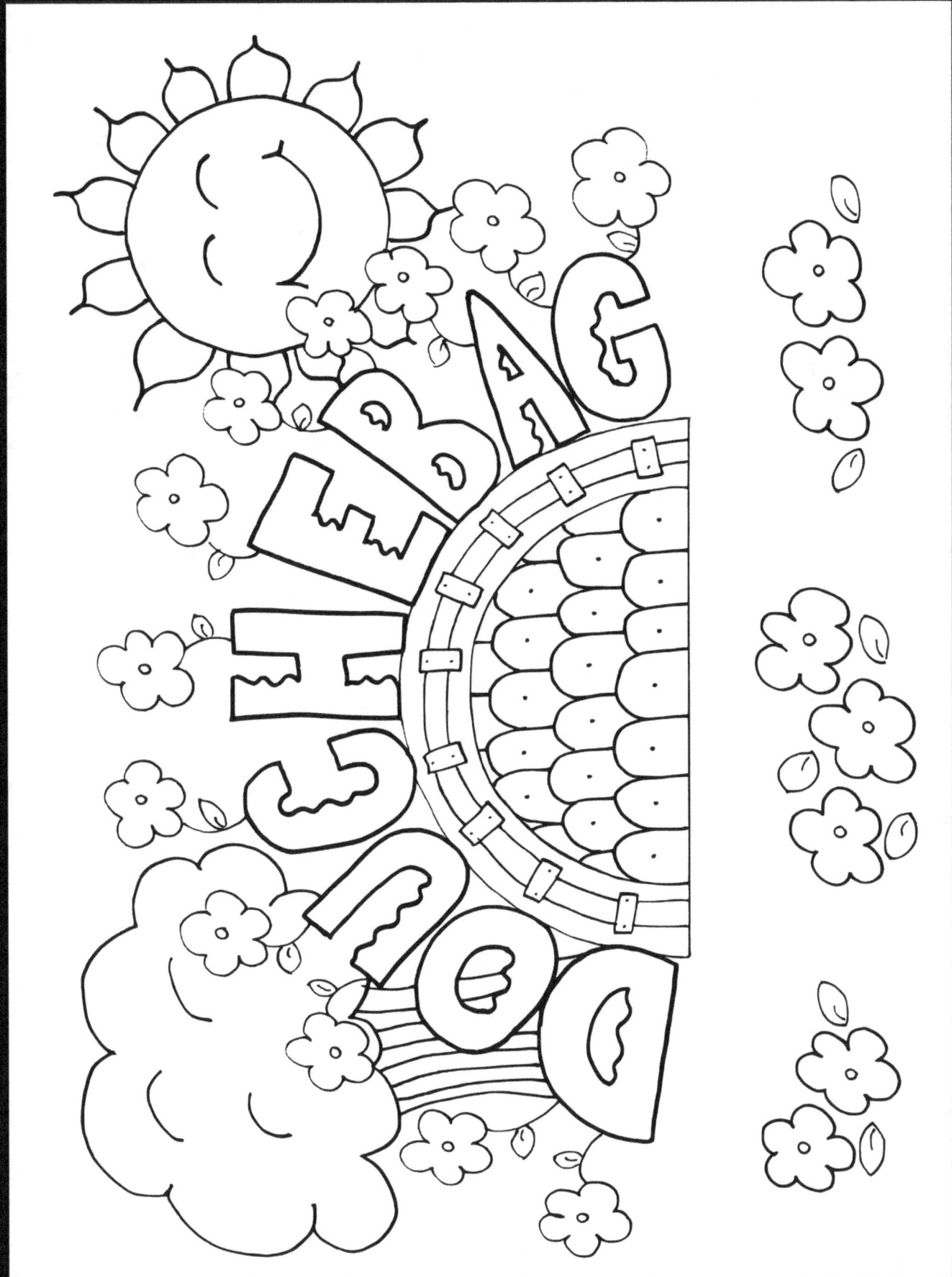

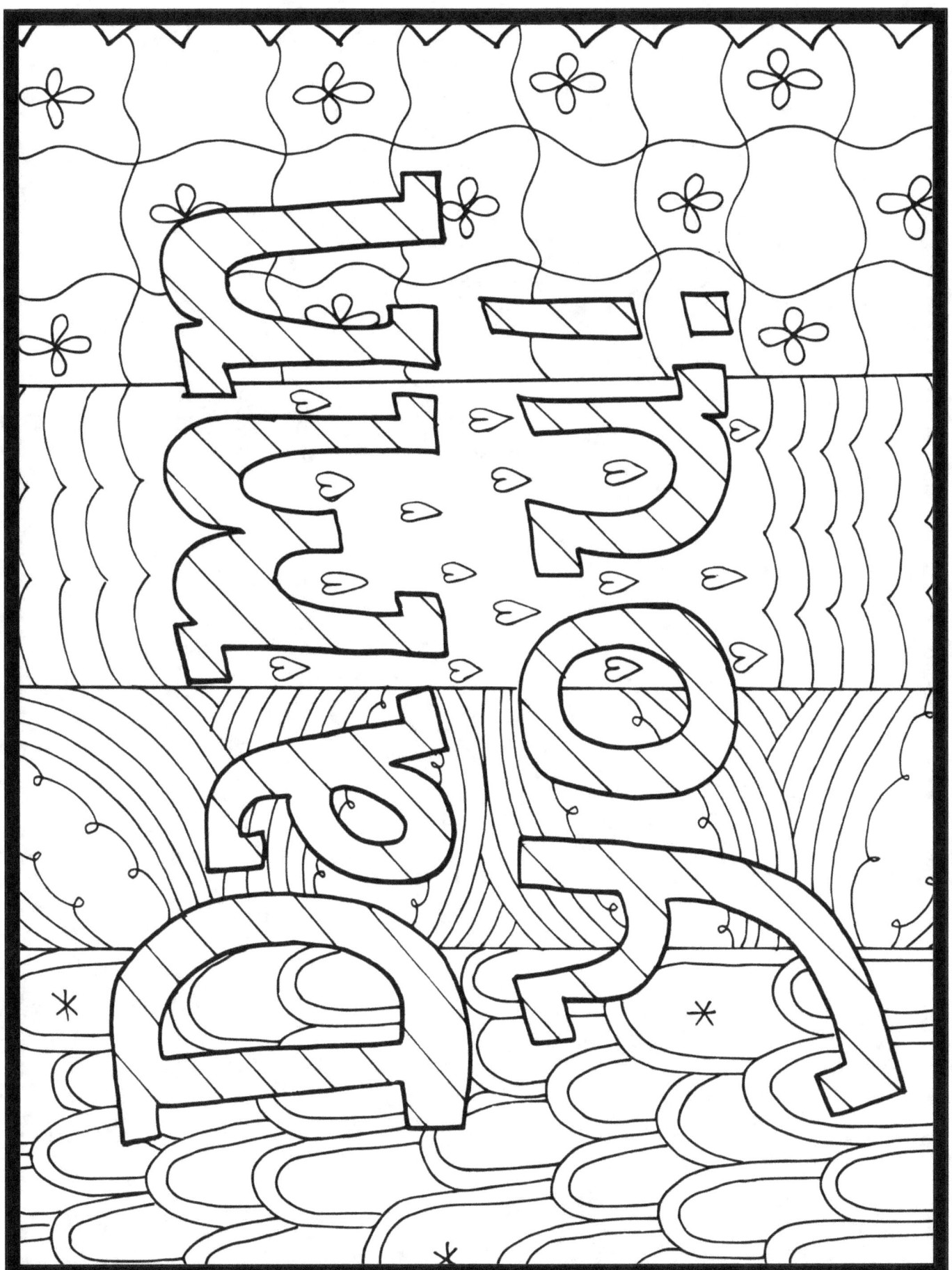

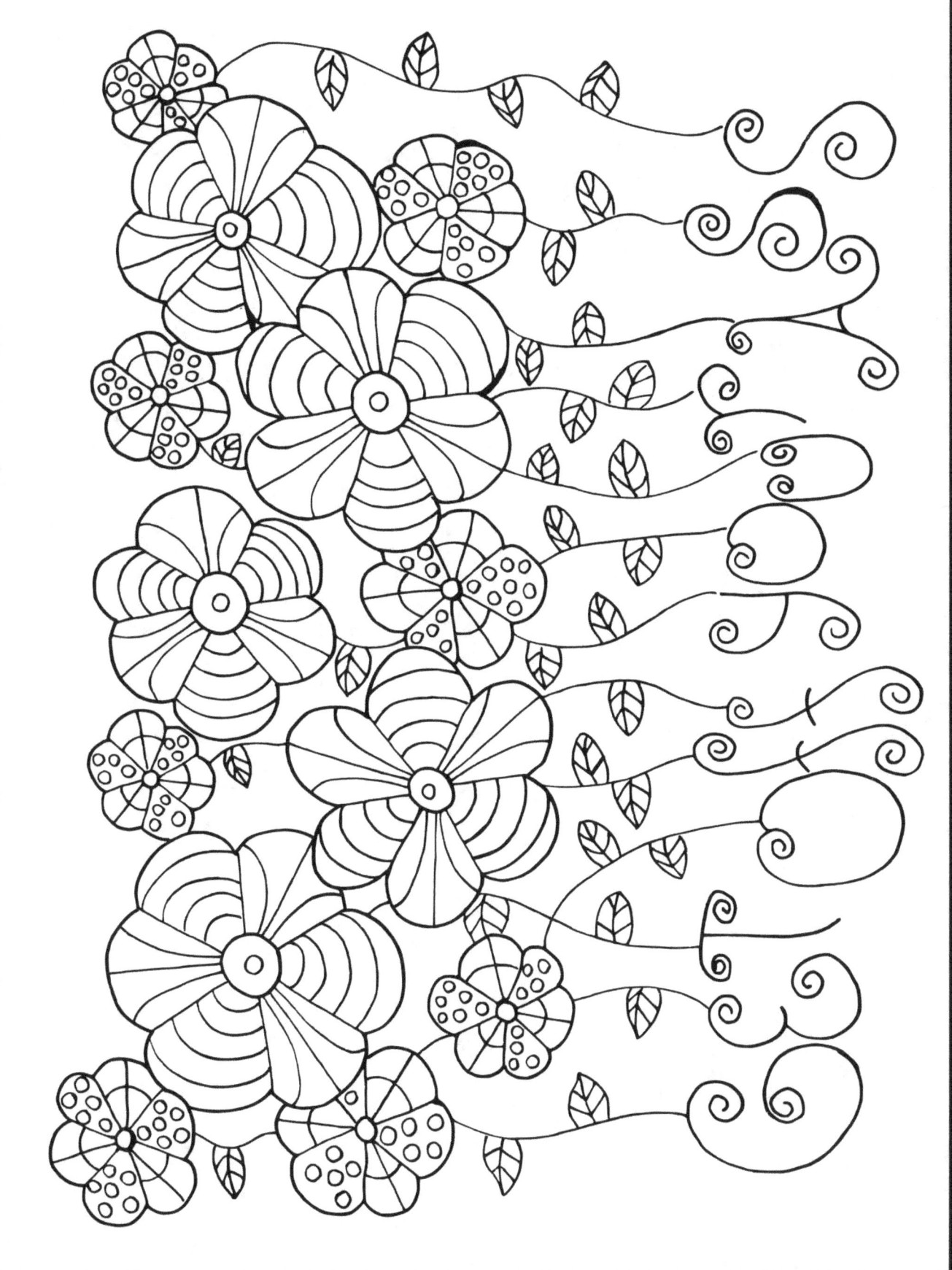

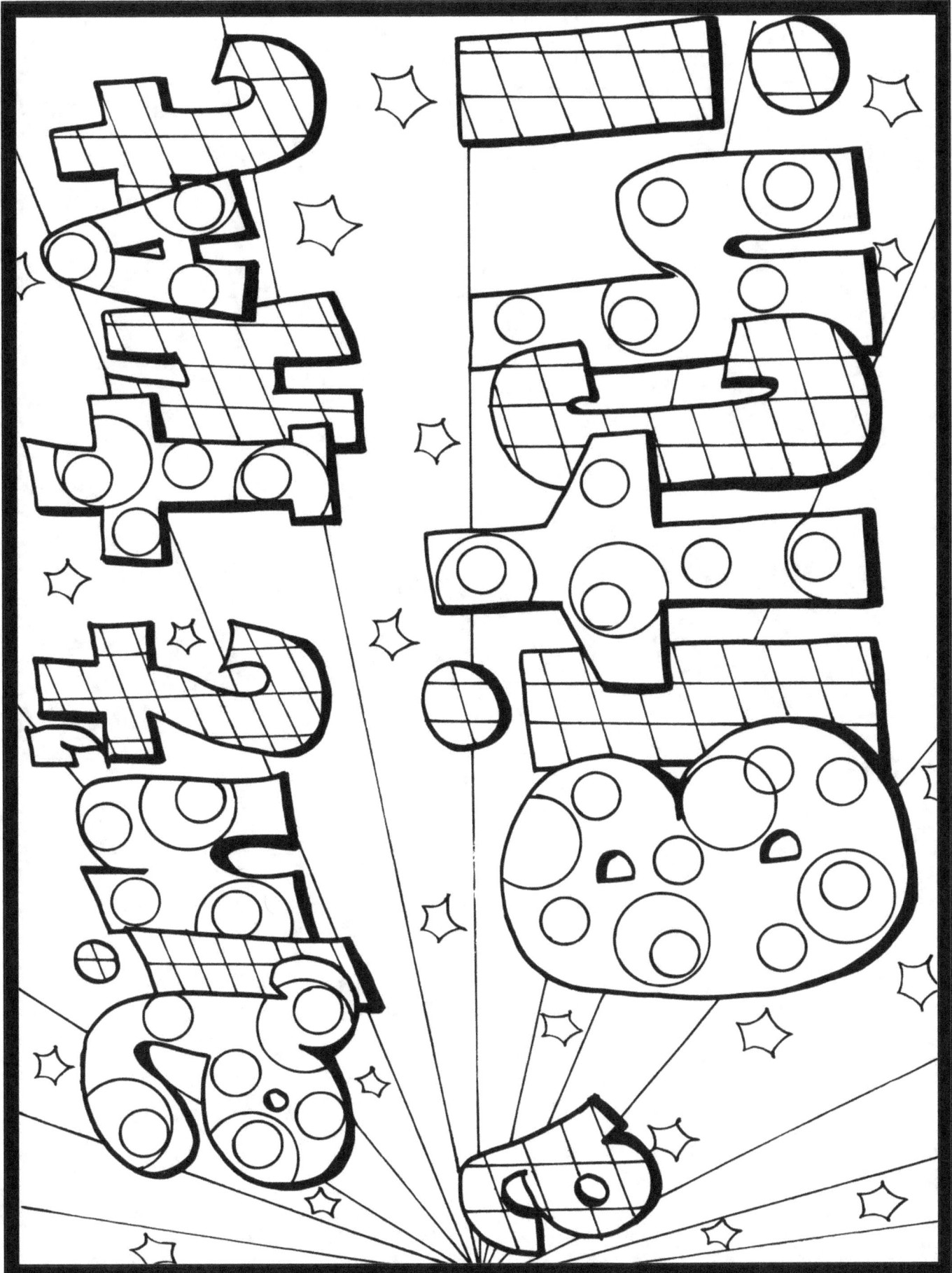

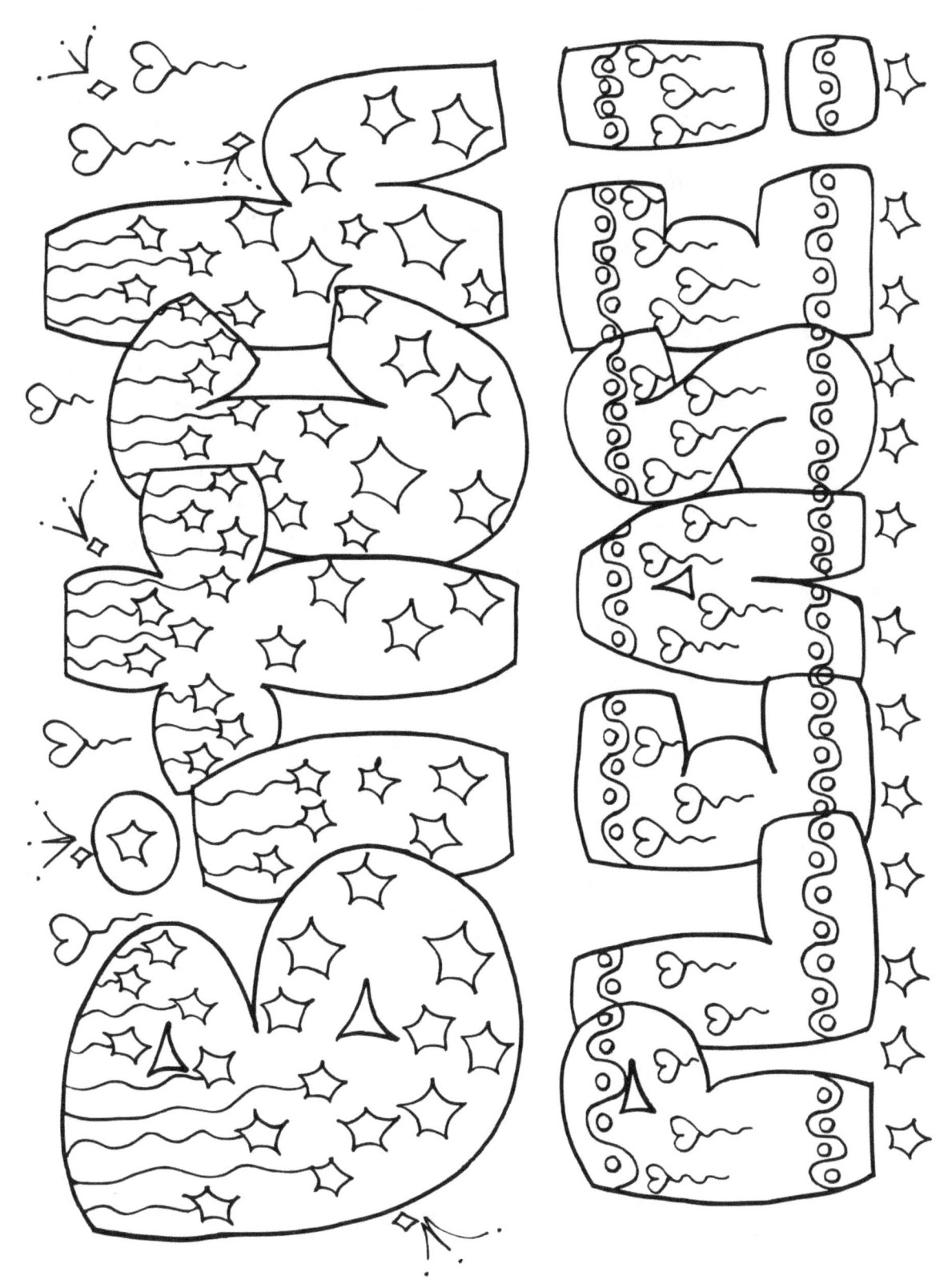

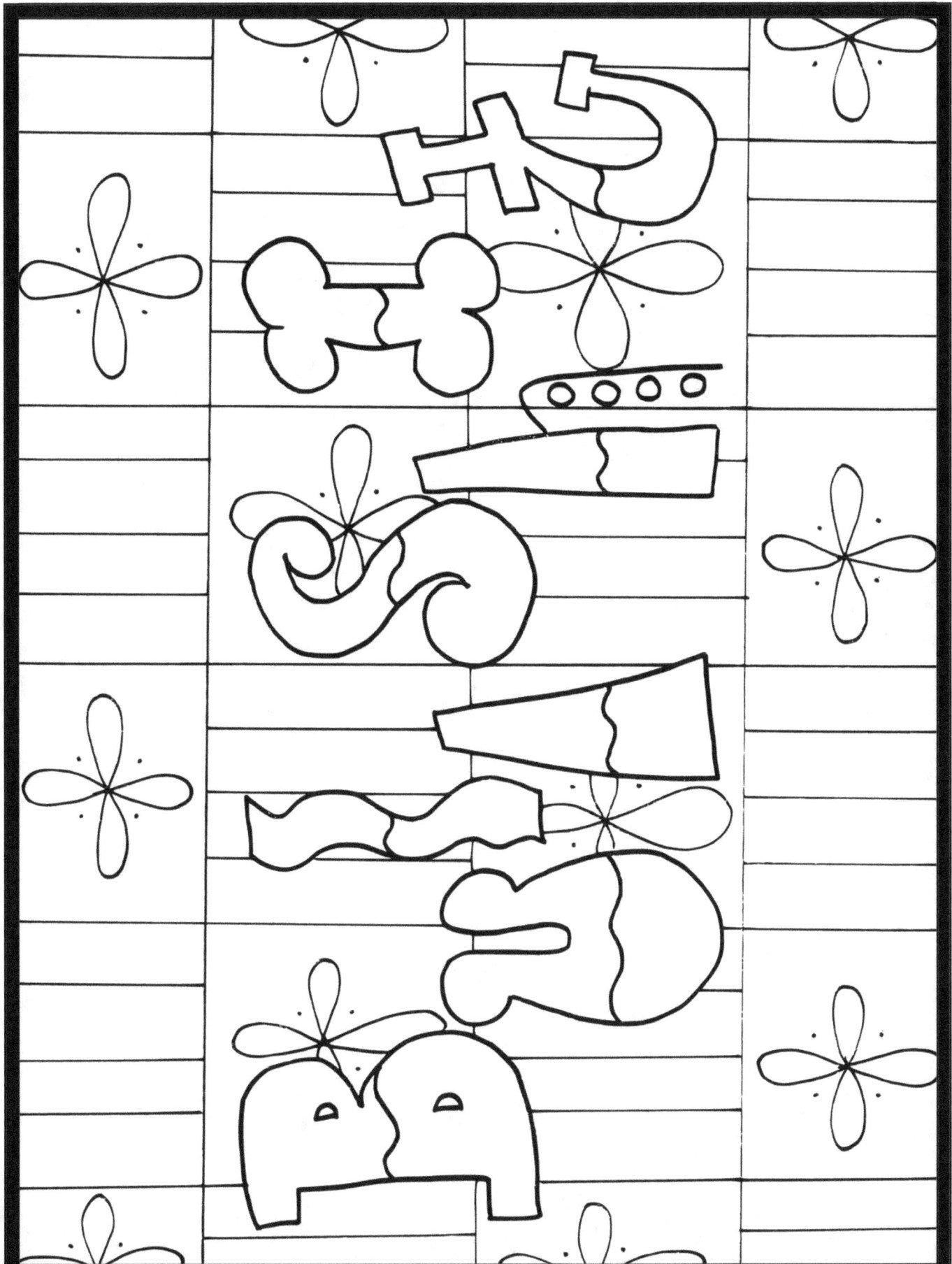

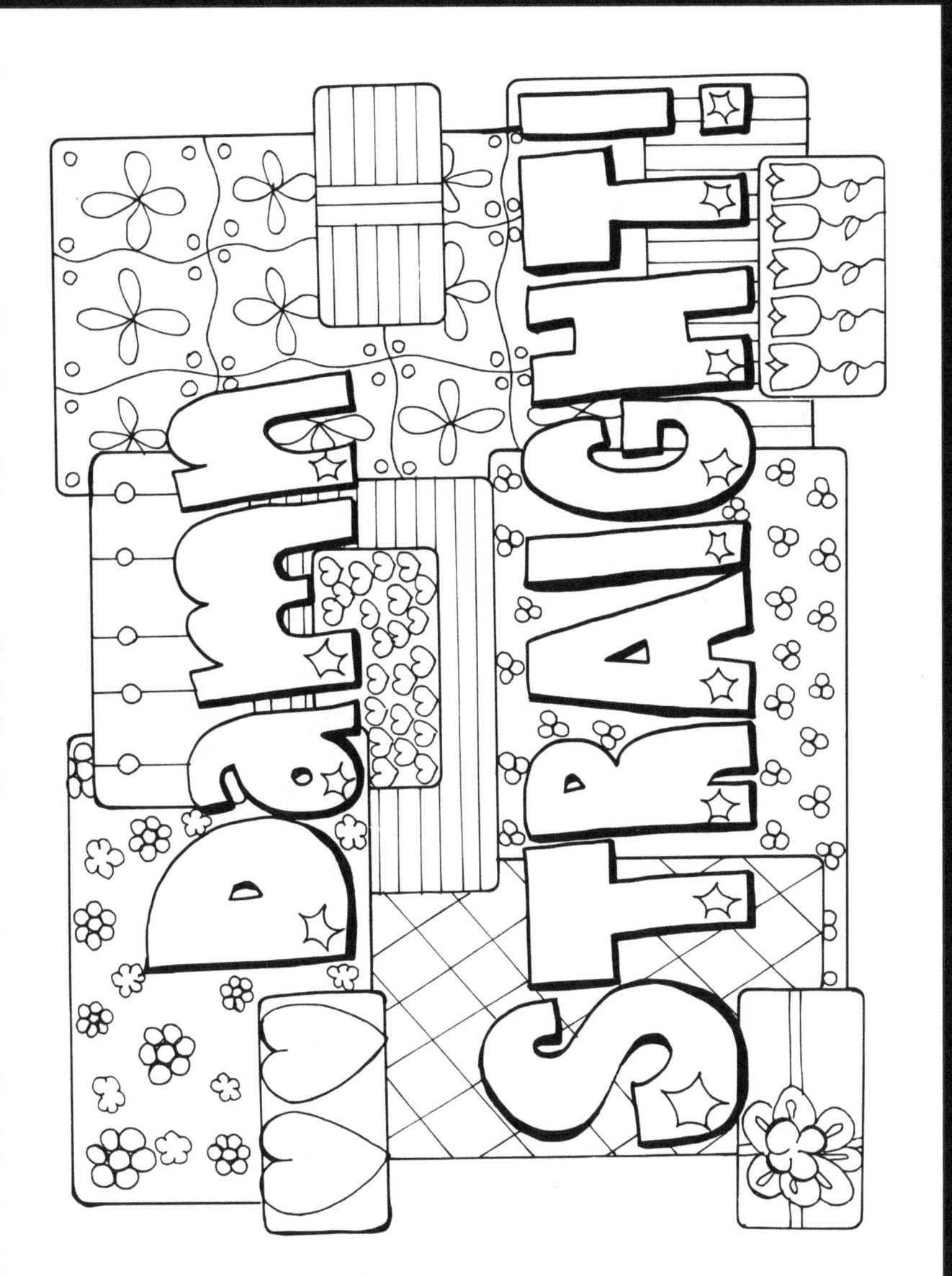

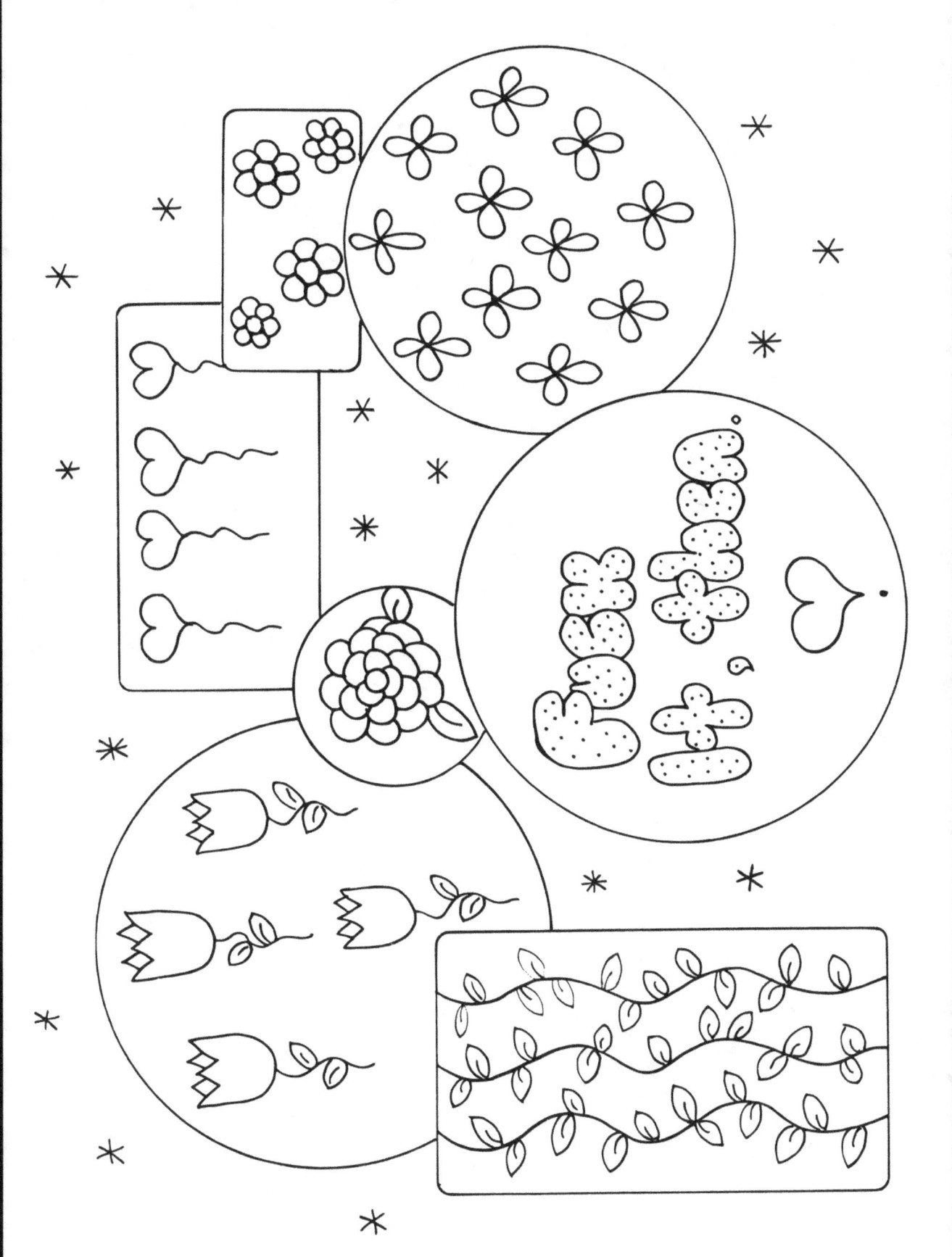

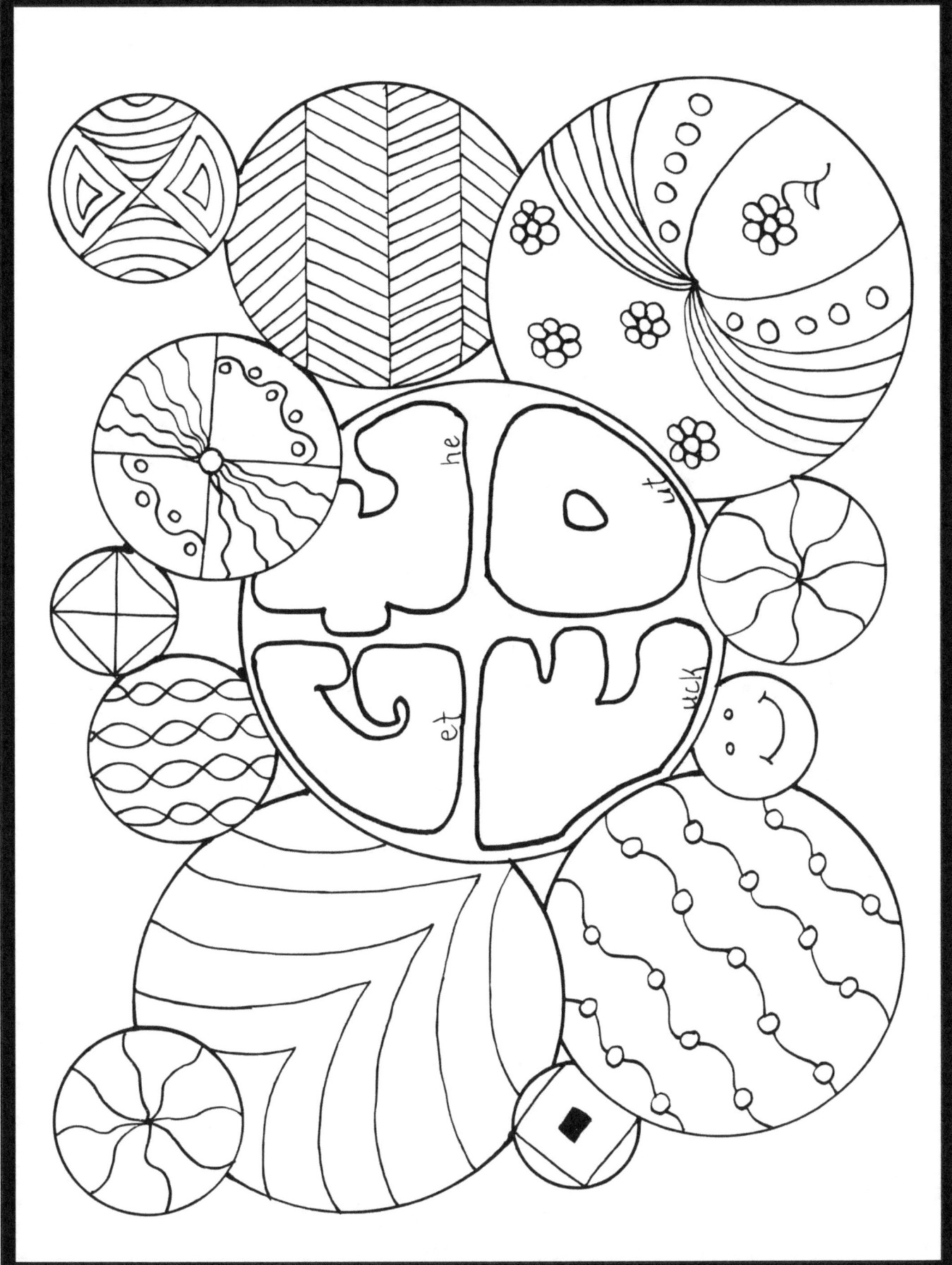

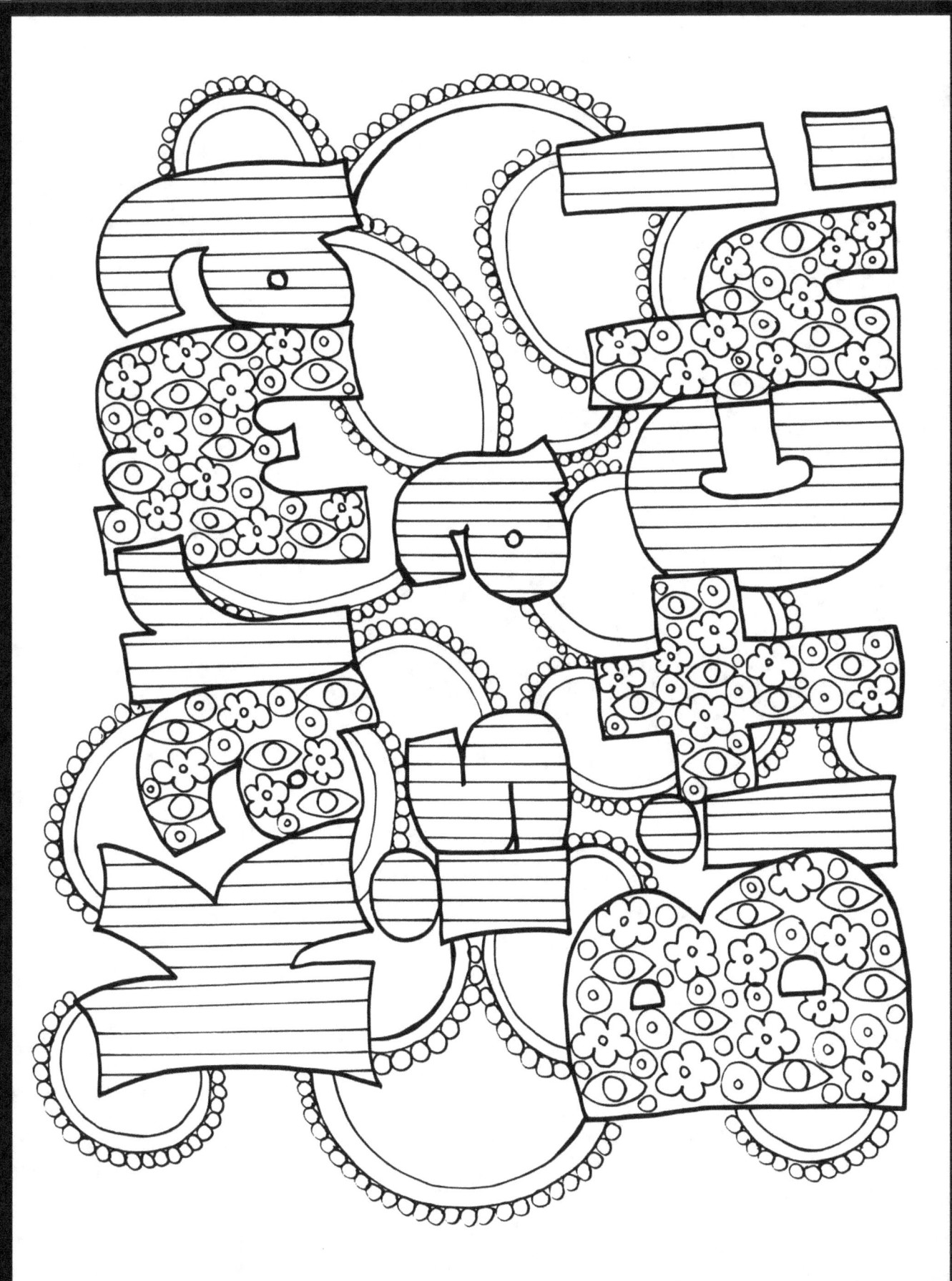

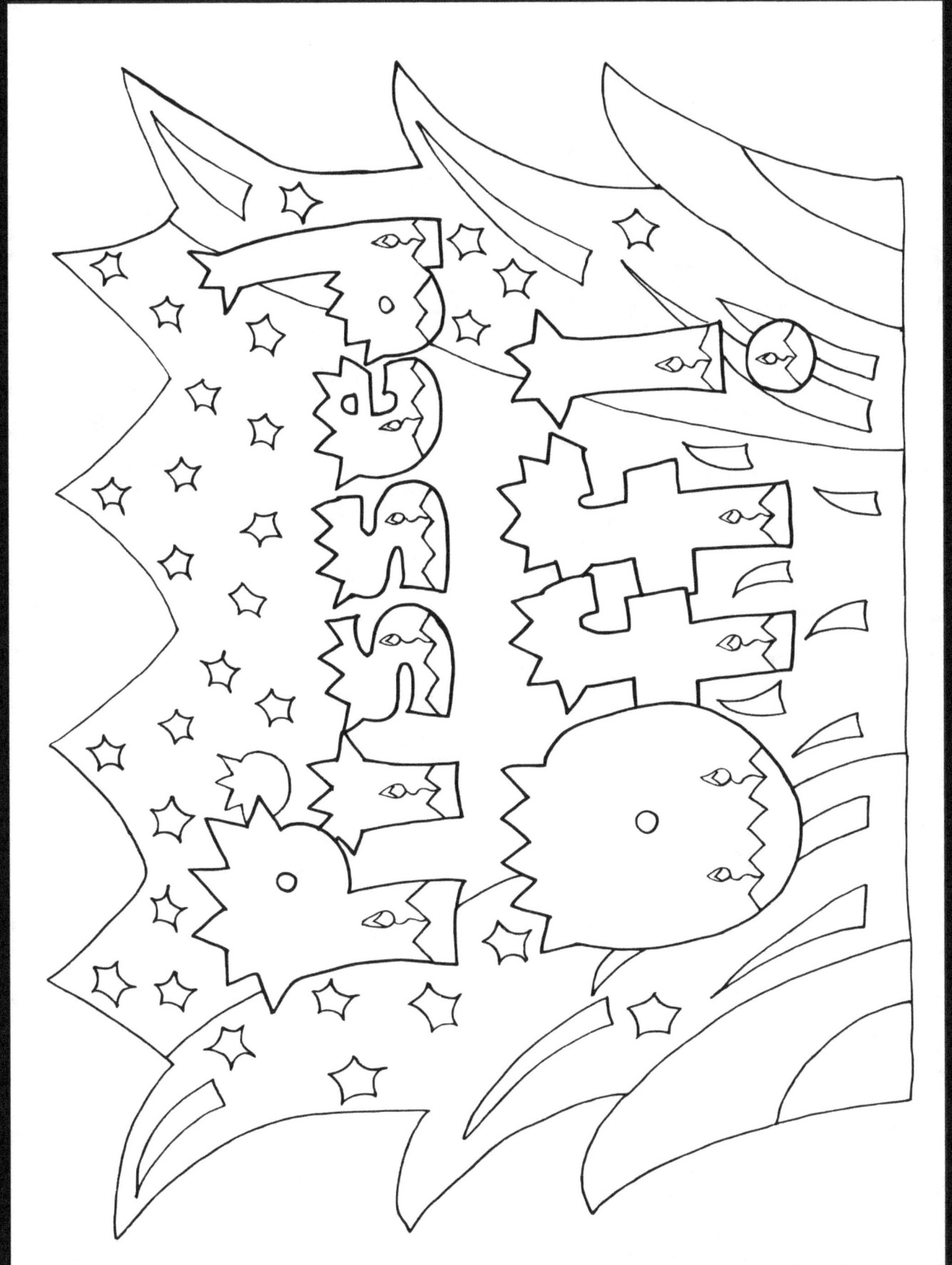

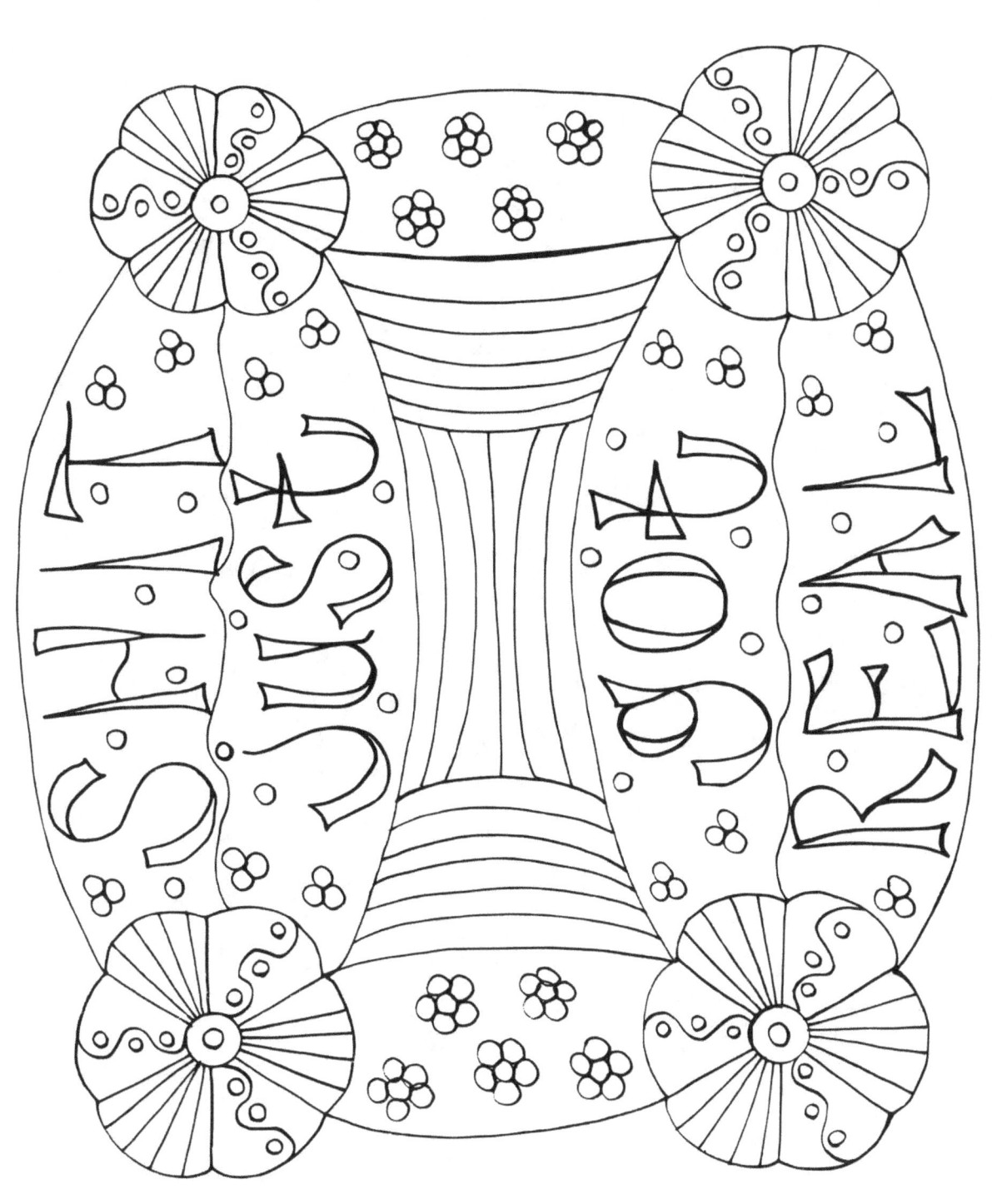

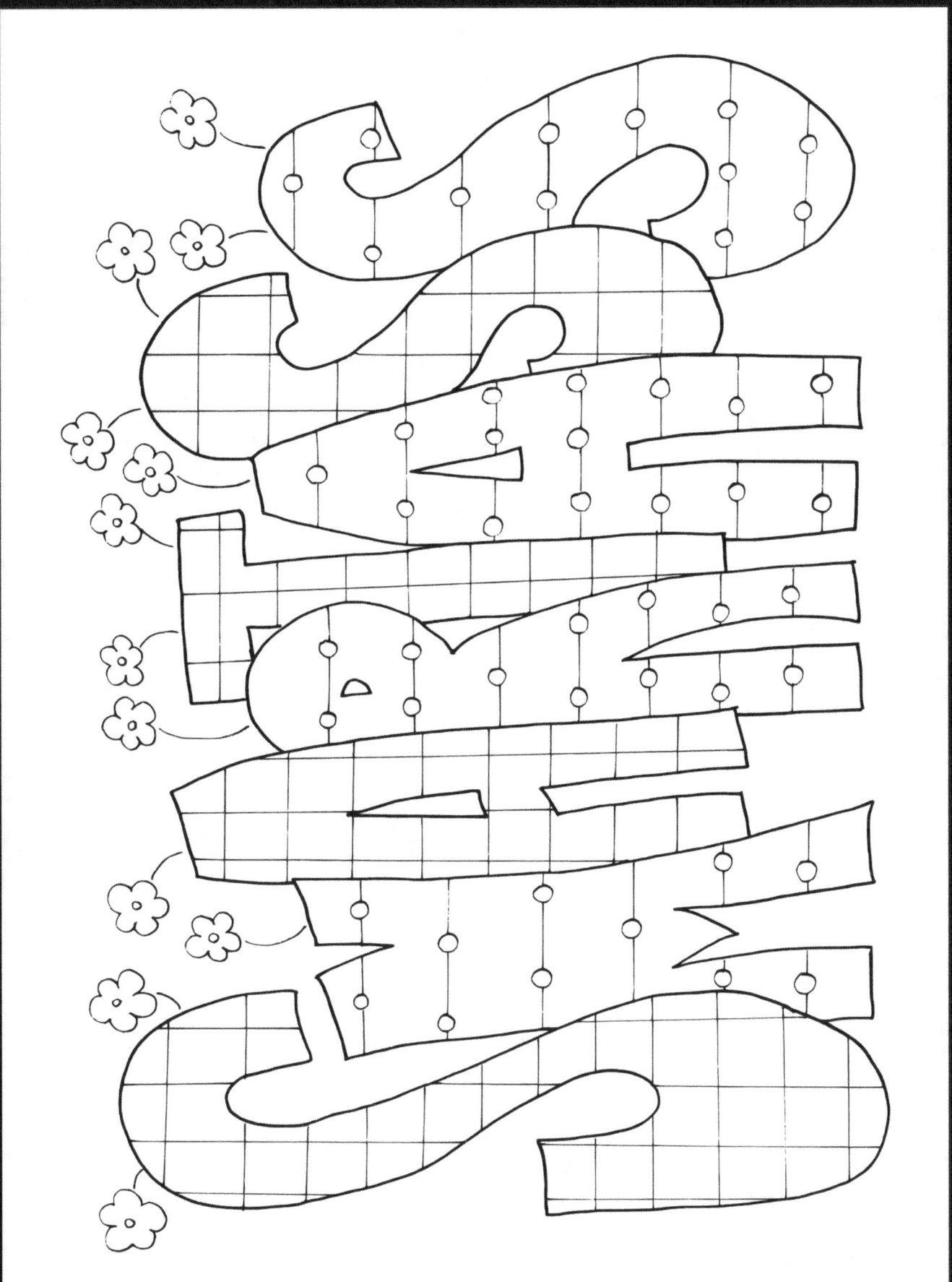